JEREMY STIFF

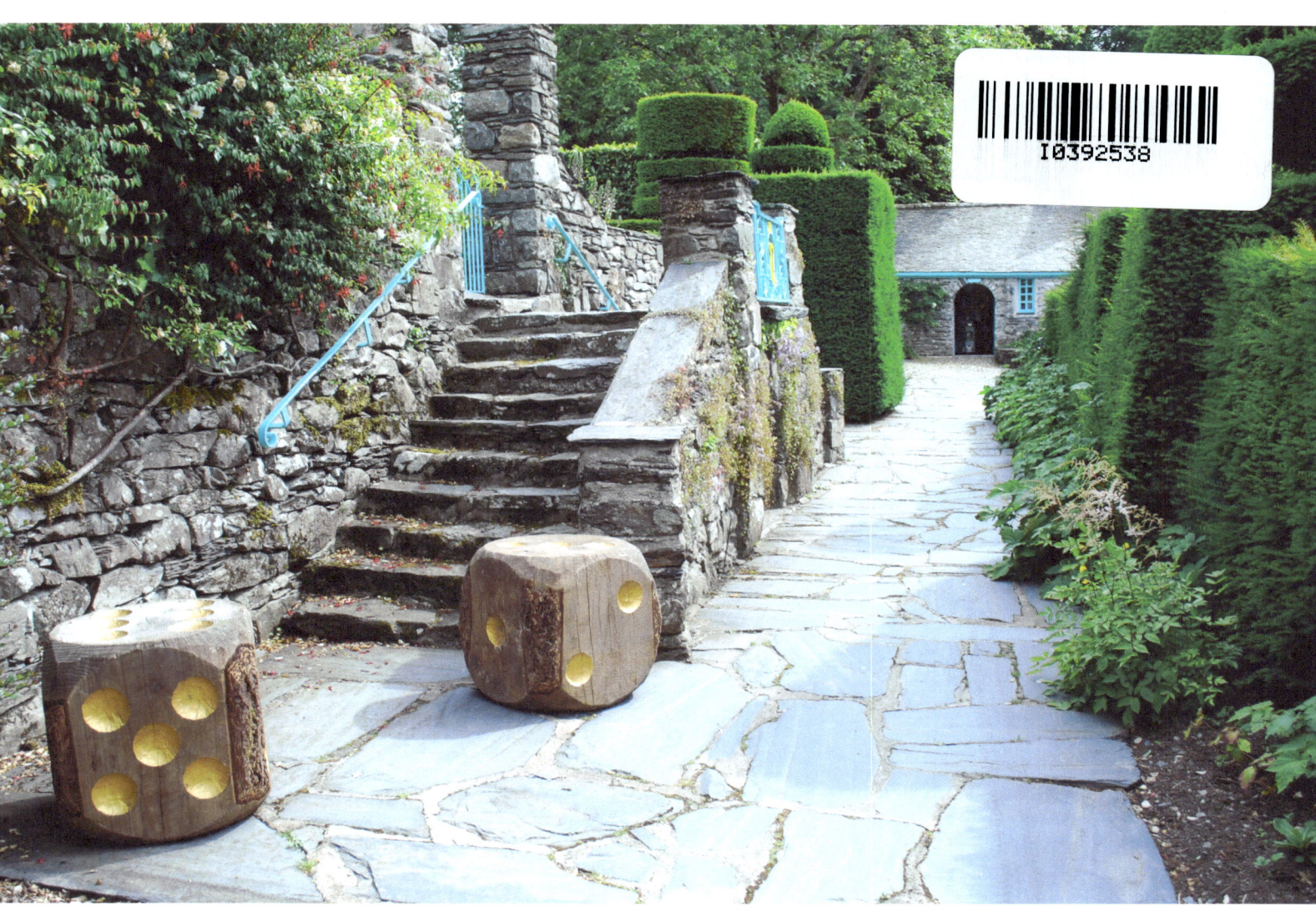

SCULPTOR

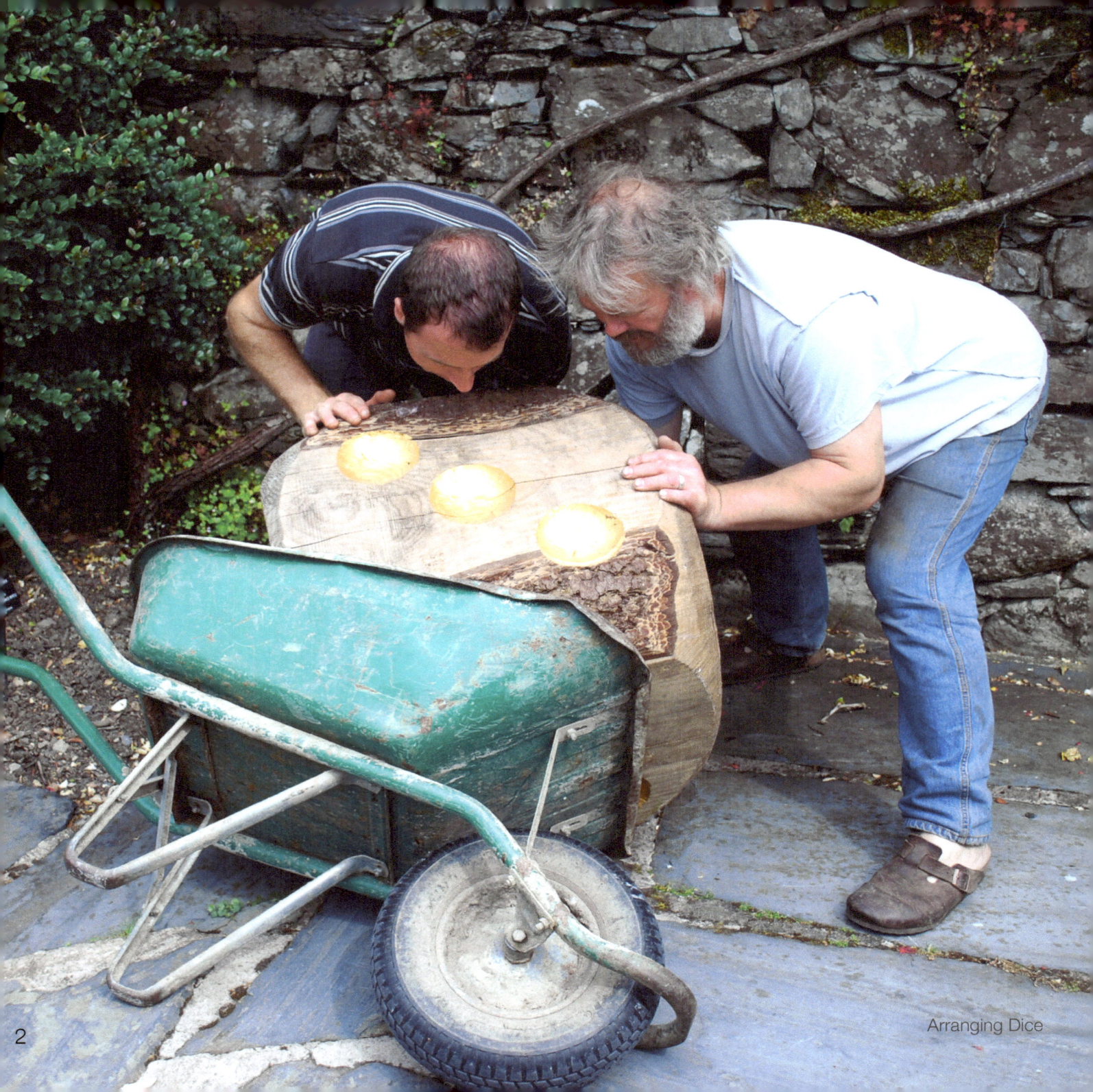

Arranging Dice

Jeremy Stiff, Sculptor

An upbringing in rural Cornwall playing among oak woods, rivers and fields gave Jem a deep love of nature and in particular of trees. At sixteen he joined his father in London for further education and then worked as a carpenter and builder. The skills he learned crystallised in time into the realisation that his connections to the natural world could be translated into sculpture.

Looking at his work now it seems to express a quiet joy in its own existence; the cat which gazes at the moon, the sock performing a stately dance in a moment when no one is looking. The care and attention which goes into carving an apparently mundane object, on one level may be seen as a joke, but on a deeper level be an invitation to consider the preciousness of time in a fleeting life and to take delight in each moment.

This book is published on the occasion of solo exhibition in the gardens laid out by the architect, Clough Williams-Ellis, at his home, Plas Brondanw in Snowdonia, North Wales.

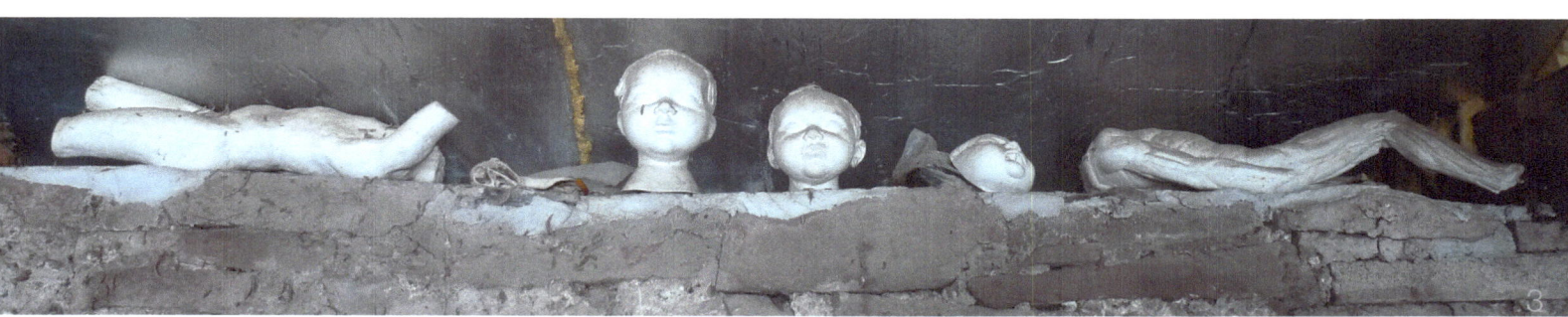

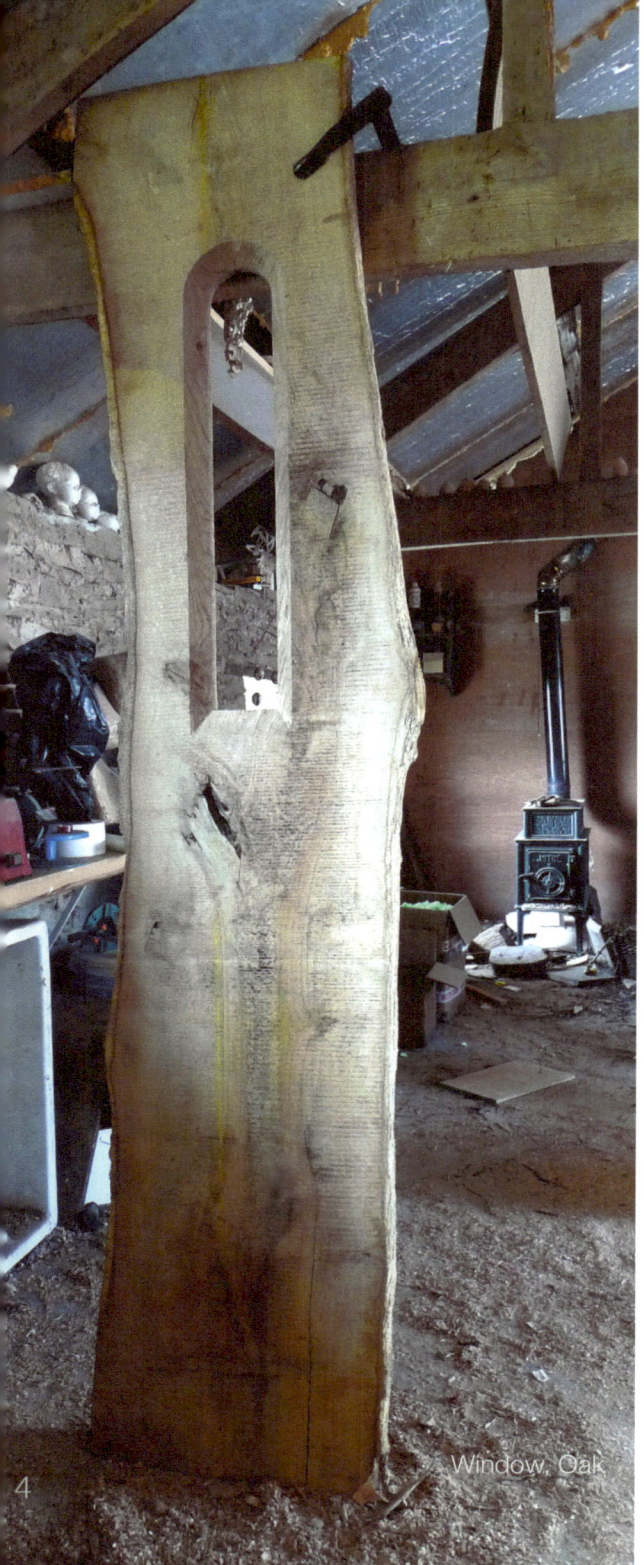
Window, Oak

About my work

I have always enjoyed making things, but making sculpture is much more interesting than making utility objects; the weaving of mundane materials with thoughts to take part in the constantly evolving dialogue of art, a language which is felt rather than heard.

In a world where an increasing portion of people's lives are spent in virtual activities, sculpture has a special quality. It occupies real space, our space; sculpture speaks on a physical level. I enjoy this shared physicality and its fundamental materiality.

Although I sometimes use materials such as clay, plaster, fibreglass, and occasionally bronze, my preferred materials are stone and wood. I like the feel, the smell, and the rich natural aesthetics which adds so much character to a piece of work. Due to the inherent qualities of wood and stone, their constant variation in colour, texture, density and grain, there are always elements of chance and change involved during the making processes. These inherent properties reduce my control over the end result and require a continual ability to modify and incorporate the unexpected which imparts qualities that cannot be measured or anticipated to the final work.

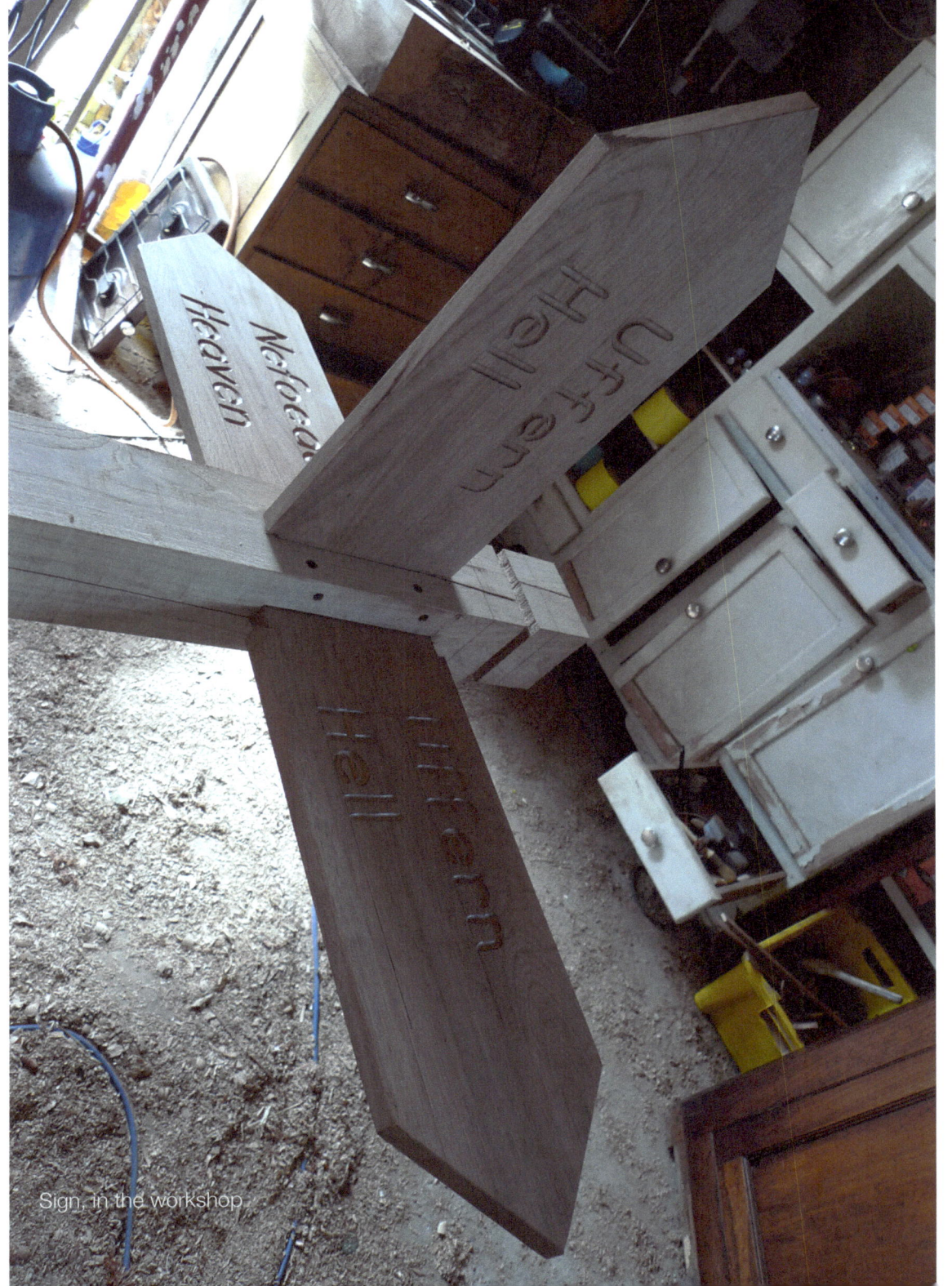

Sign, in the workshop

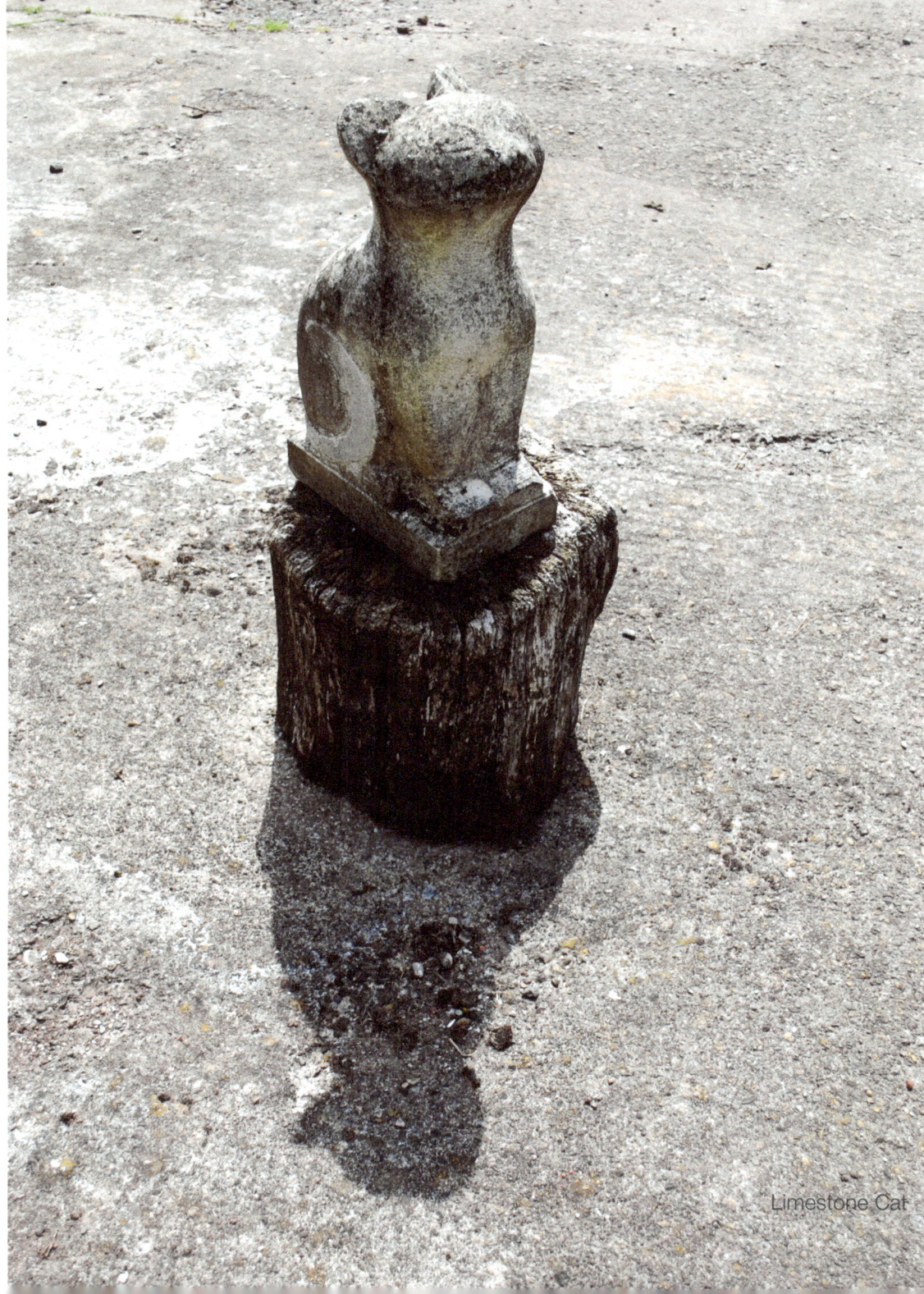
Limestone Cat

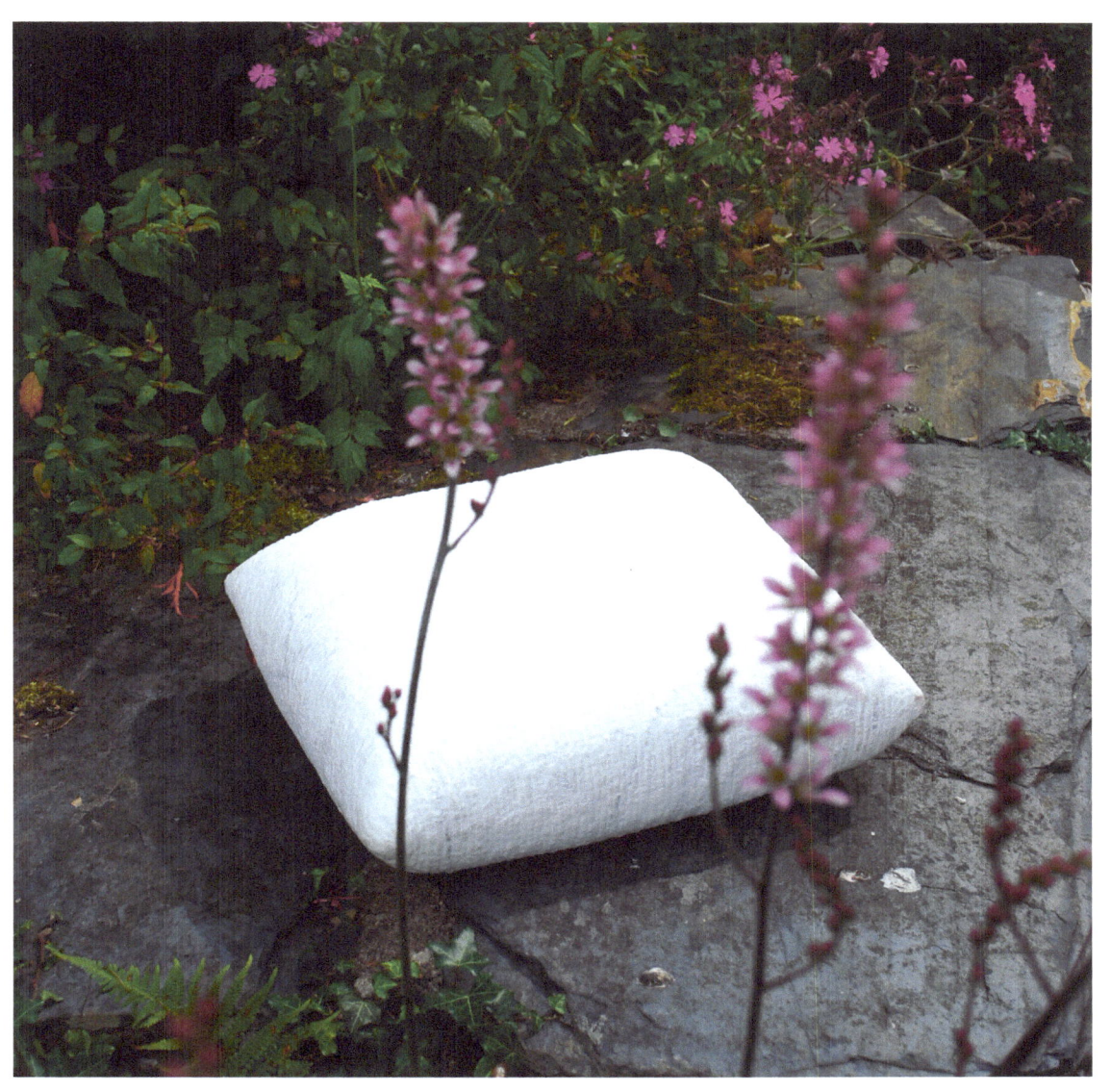

Marble Cushion

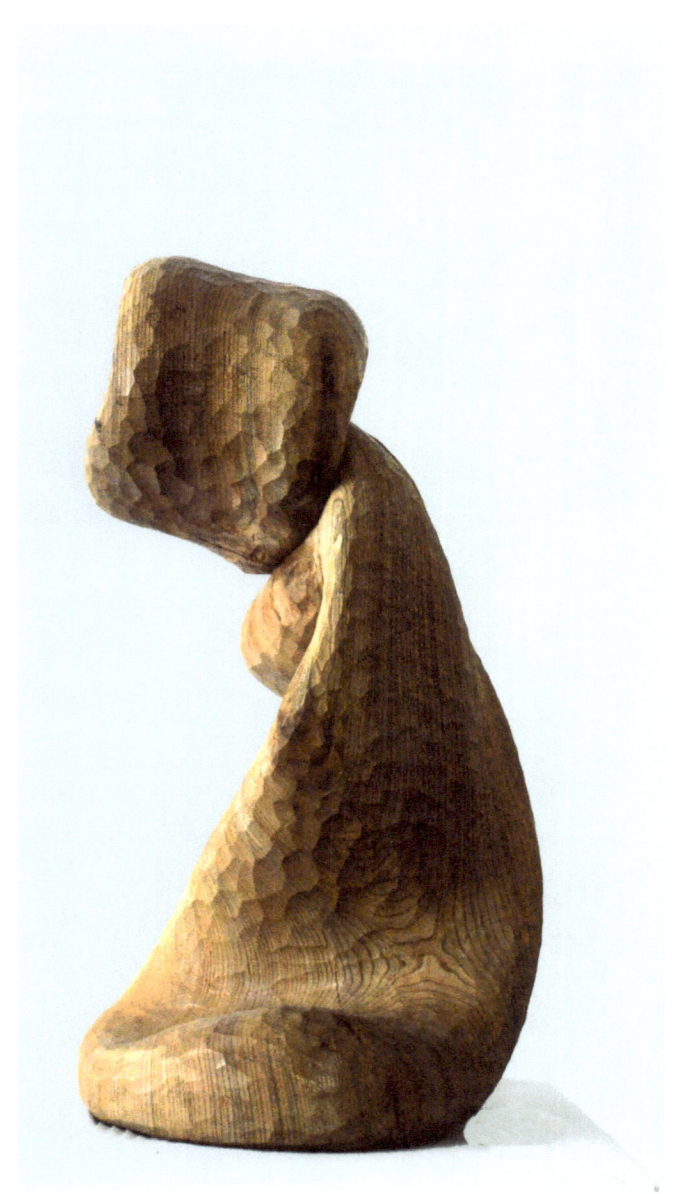
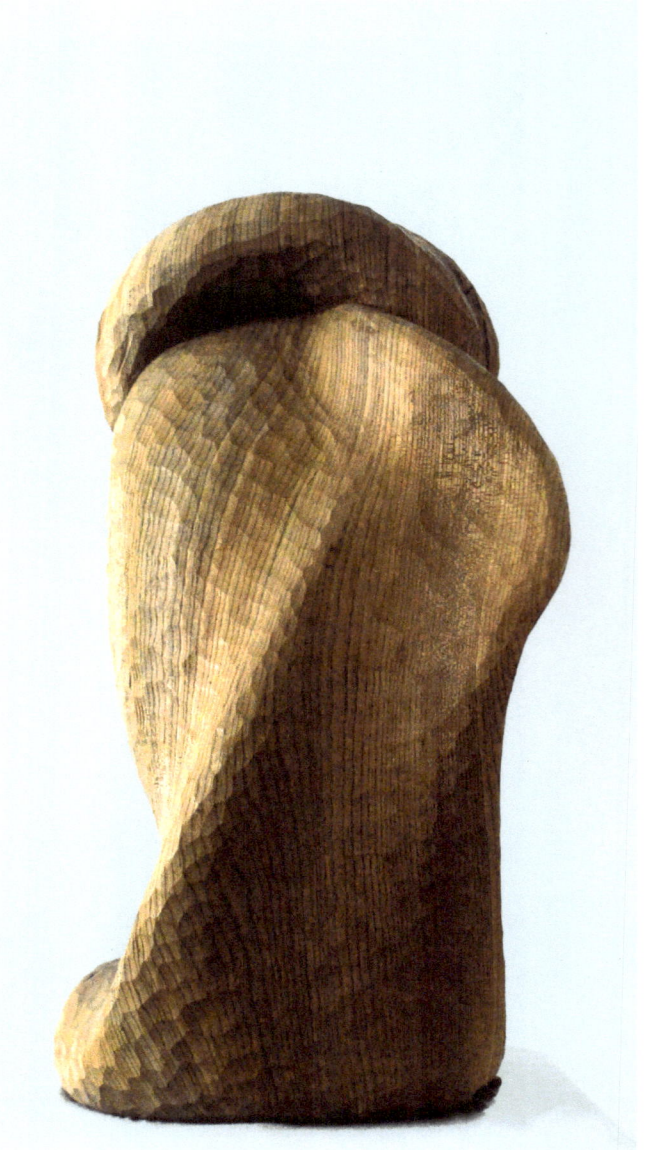

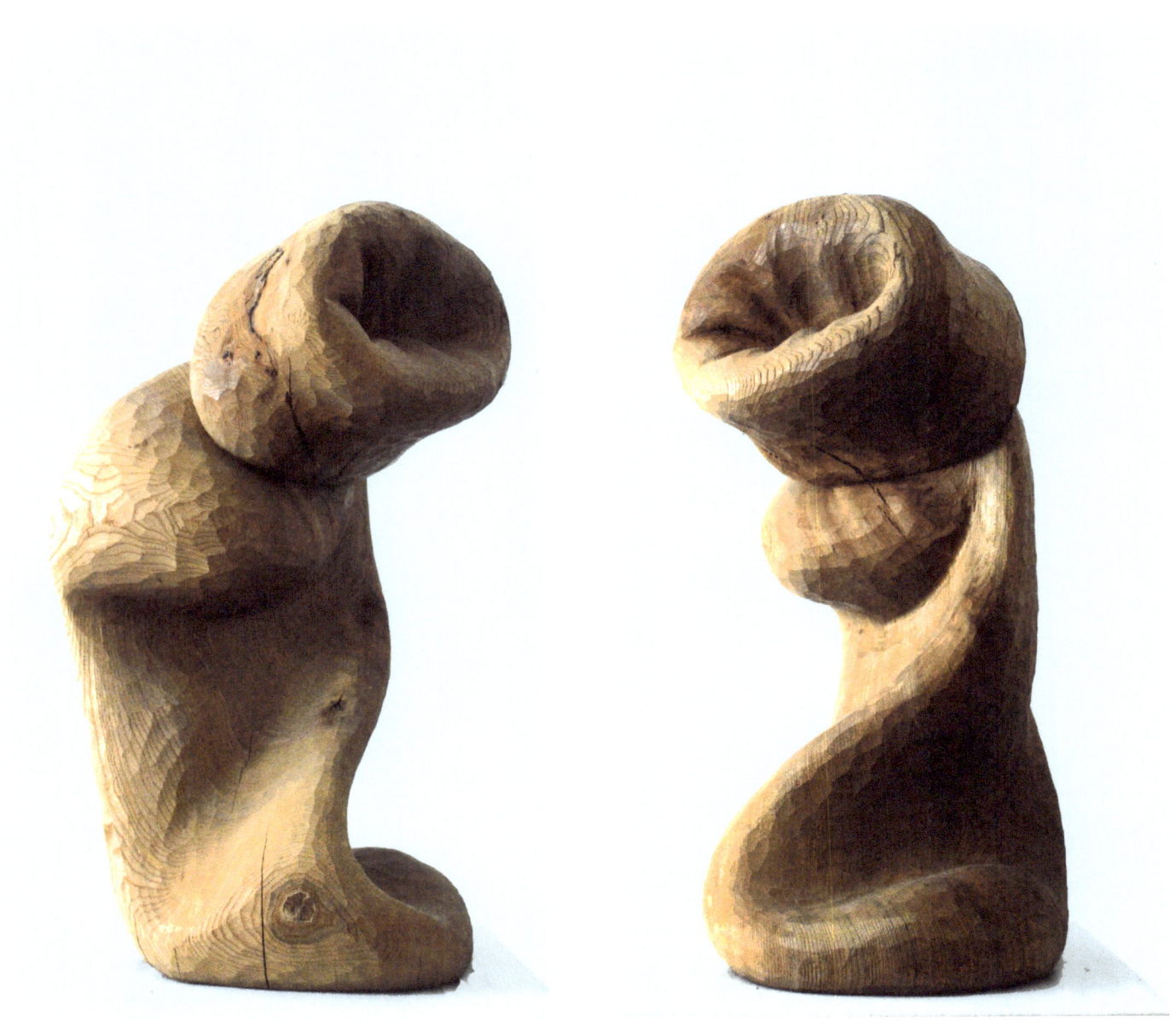

Dancing Sock, Elm

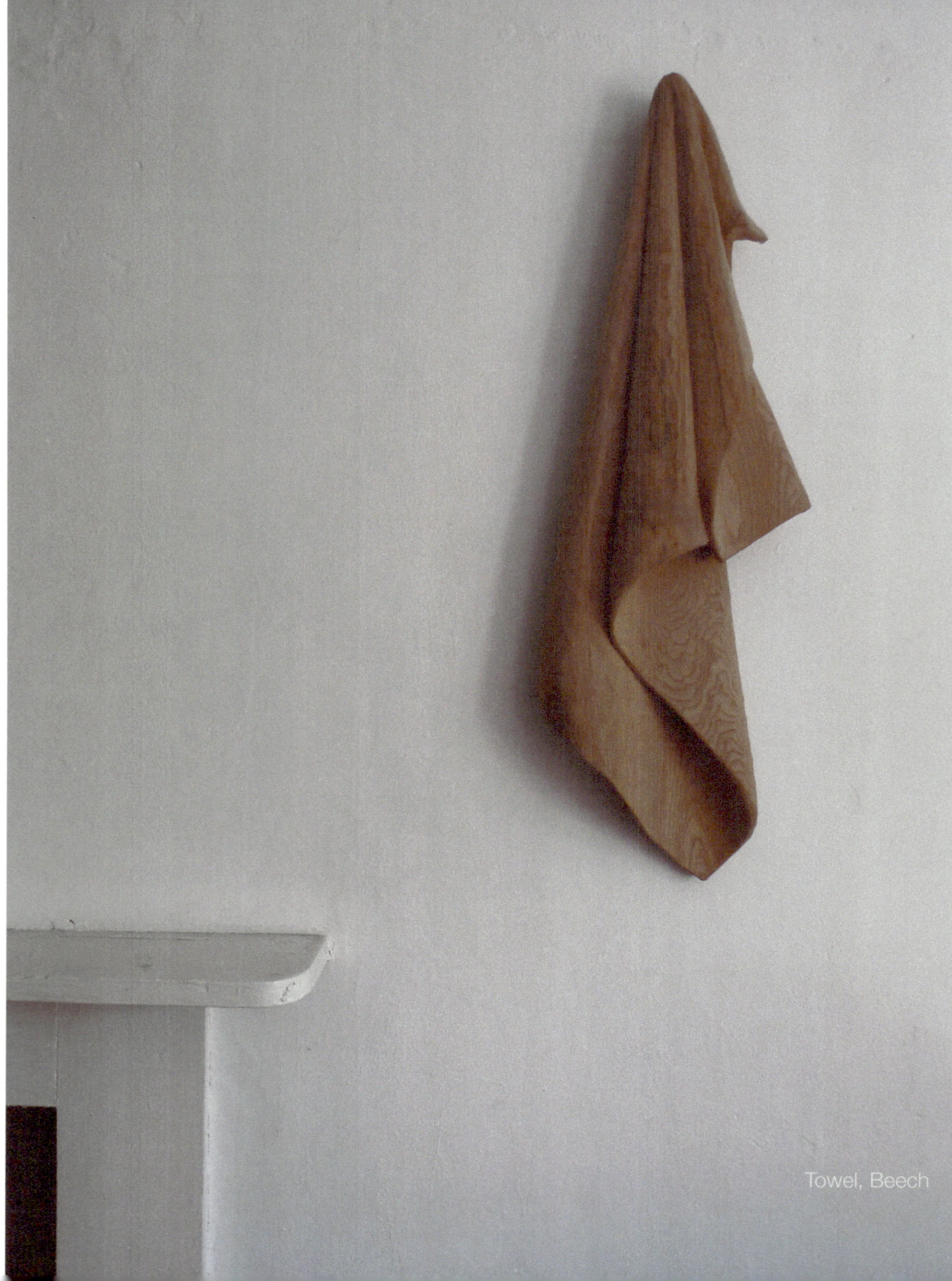

Towel, Beech

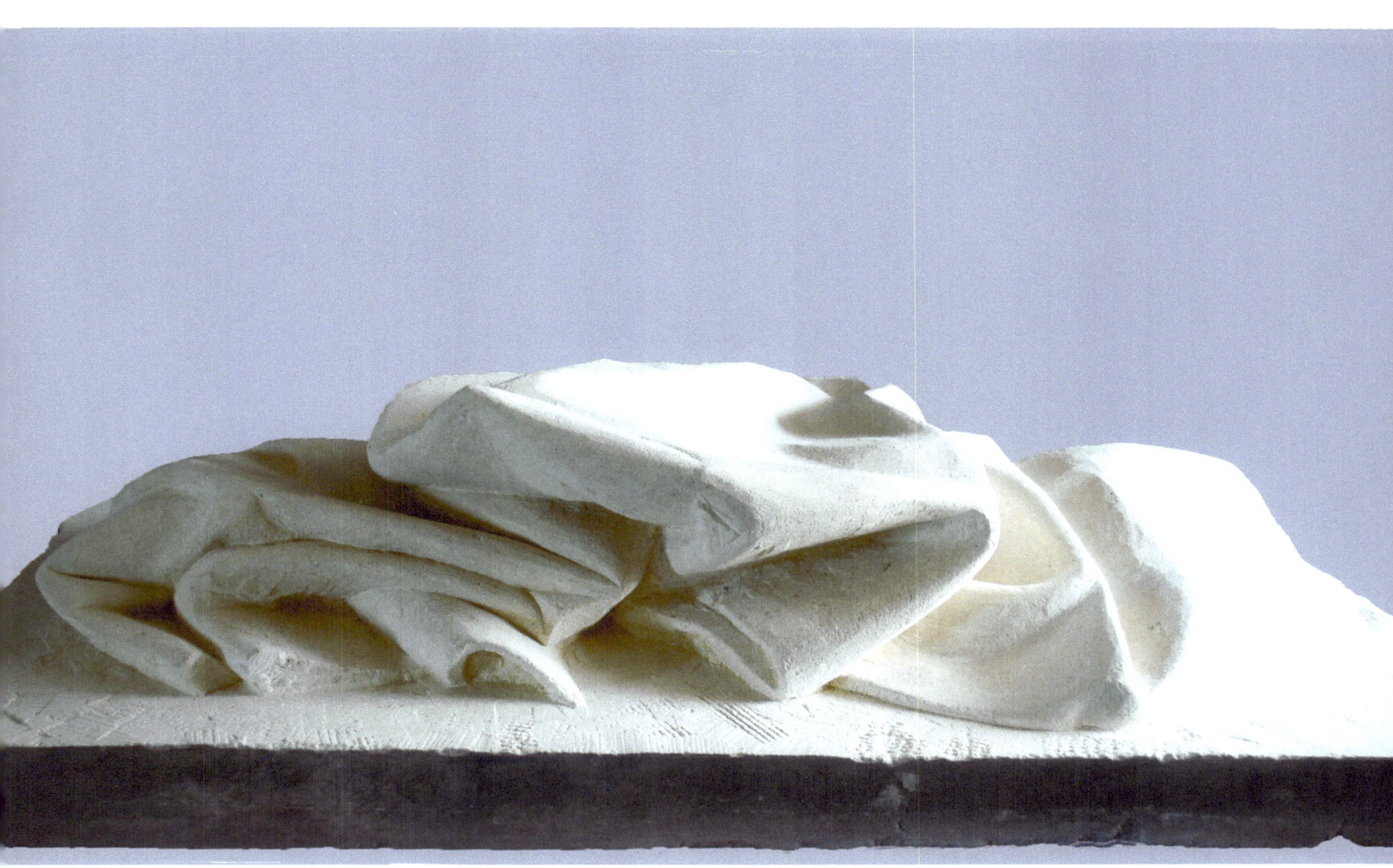

Cloth, Limestone

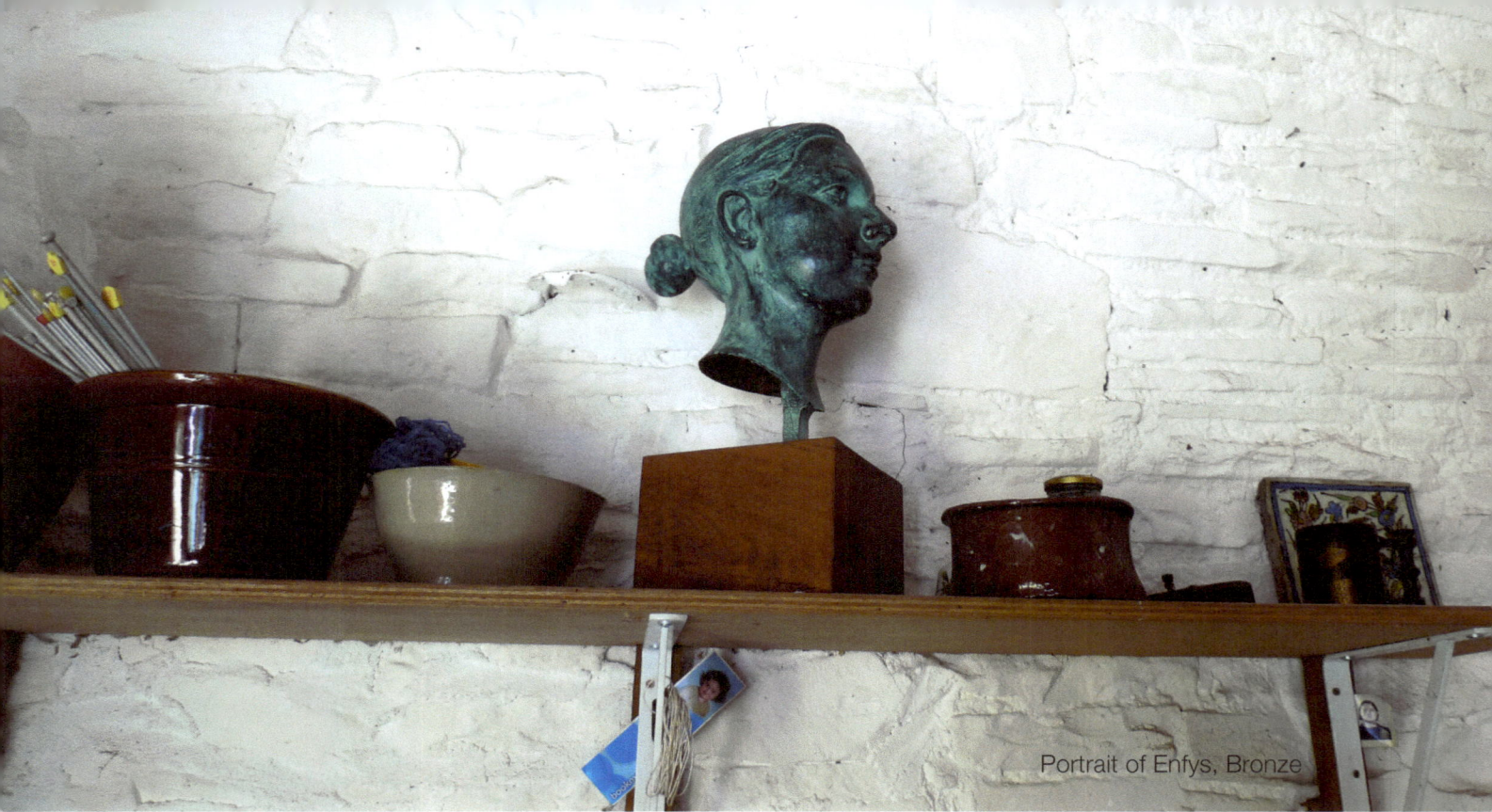

Portrait of Enfys, Bronze

Working with everyday domestic objects has deep interests, the ordinary when carved can become extraordinary. The importance of everyday items is overlooked; they are in fact main players in our day to day existence. These props are all part of our daily domestic activity, They are surrounded by memories and loaded with promise.

The still life in art has posed a subtle alternative to the grand gesture; triumphant heroes, lascivious, sprawling gods, endless unsullied landscapes. Still life offers instead a tranquillity, a small intimate space to enter momentarily; a space which allows private feelings; feelings that are often not verbalised, the passing of time, empathy for others and life as a shared experience.

How many of us appreciate our pillow where we rest our heads for a third of our time, where most of us will end our lives. At the end of the day most people look forward to laying their head on a pillow; as with friends, we enjoy the intimate moments together.

On a formal level the carving of socks was an exercise in looking and translation. I hugely enjoyed the hours spent getting to know the material forms of these mundane subjects. Making portraits of socks seems to mock traditions of heroic sculpture, elevating the status of these humble objects. Isn't a sock worth celebrating for its heroic duties?

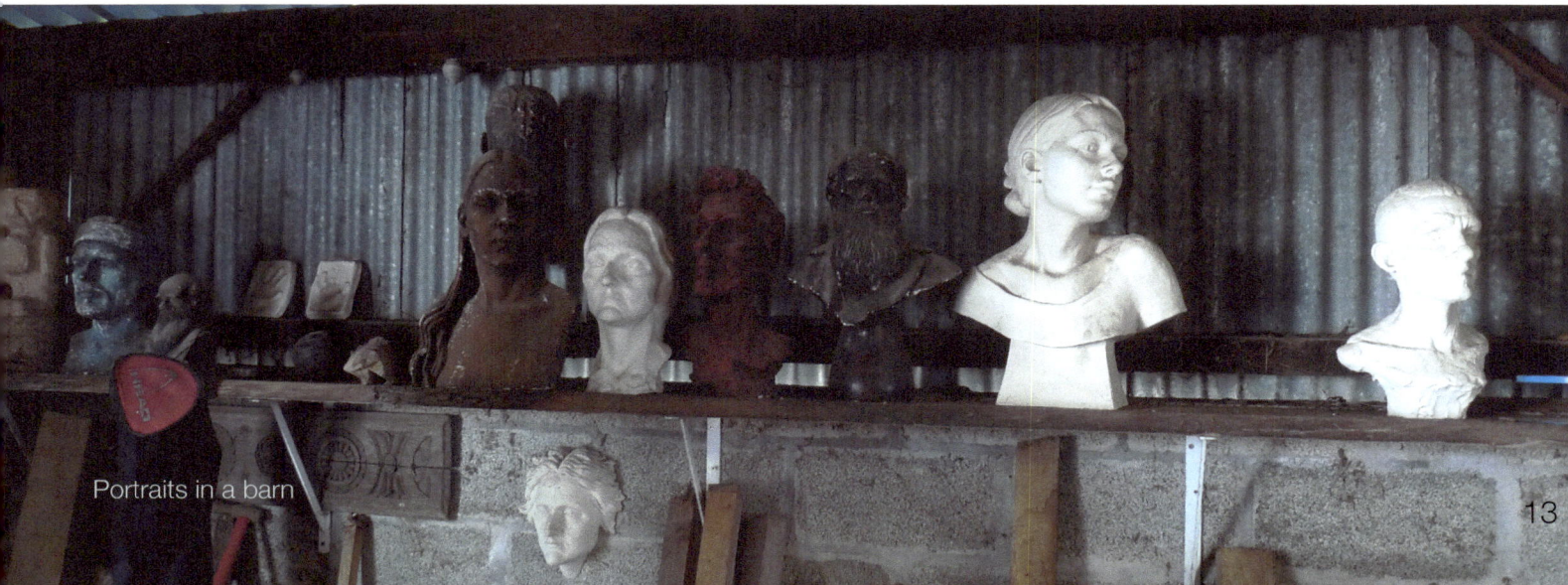

Portraits in a barn

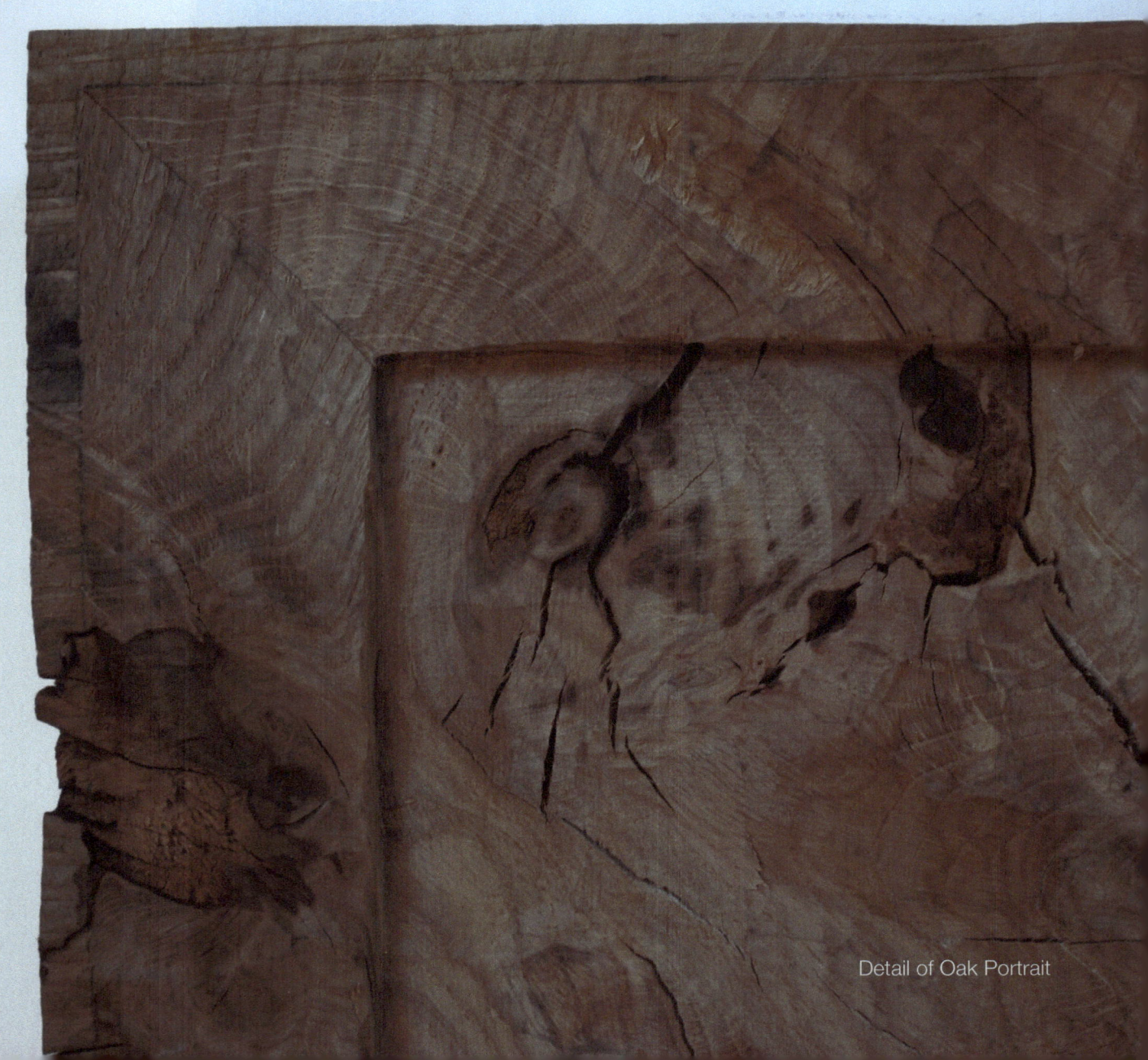

Detail of Oak Portrait

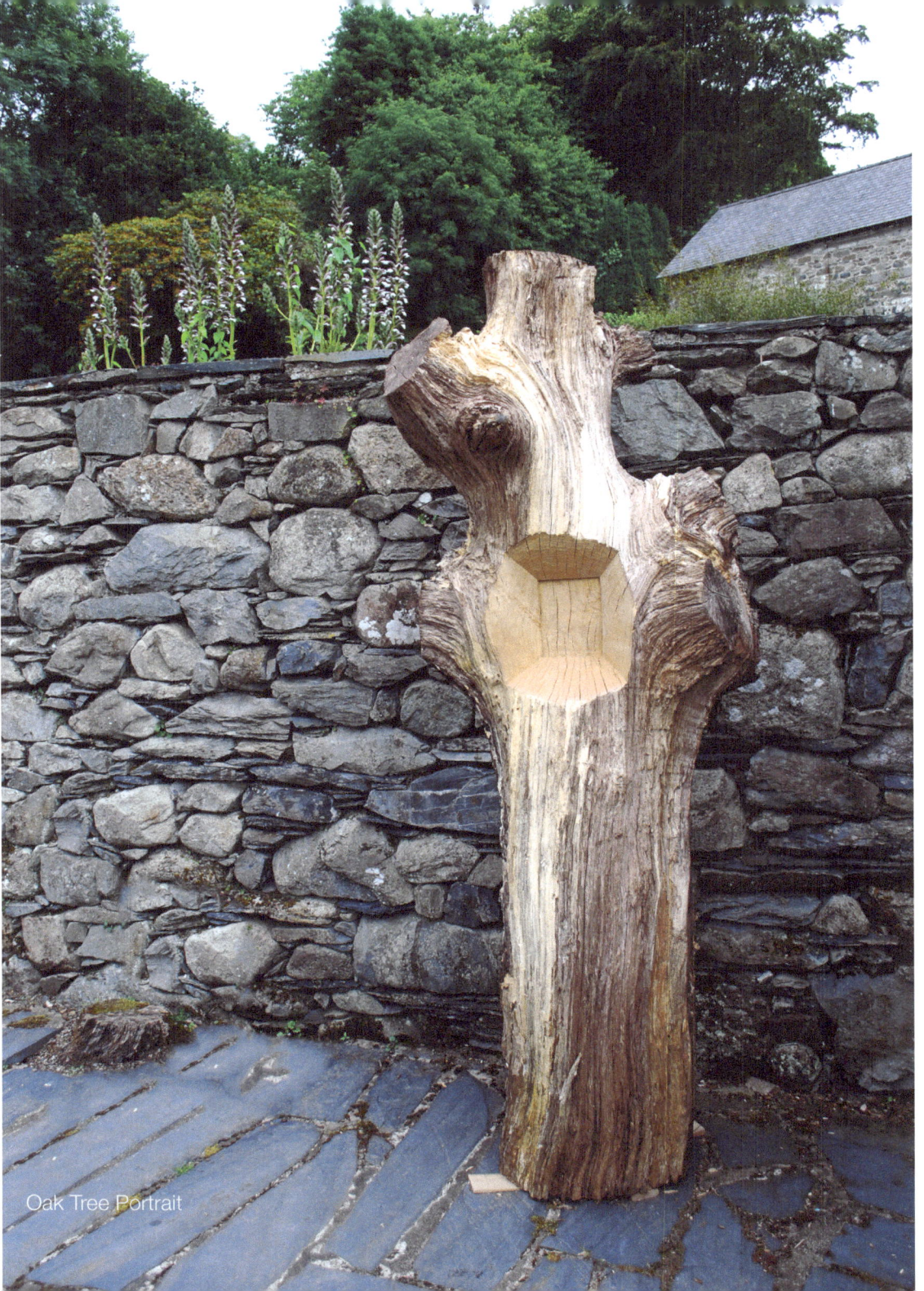
Oak Tree Portrait

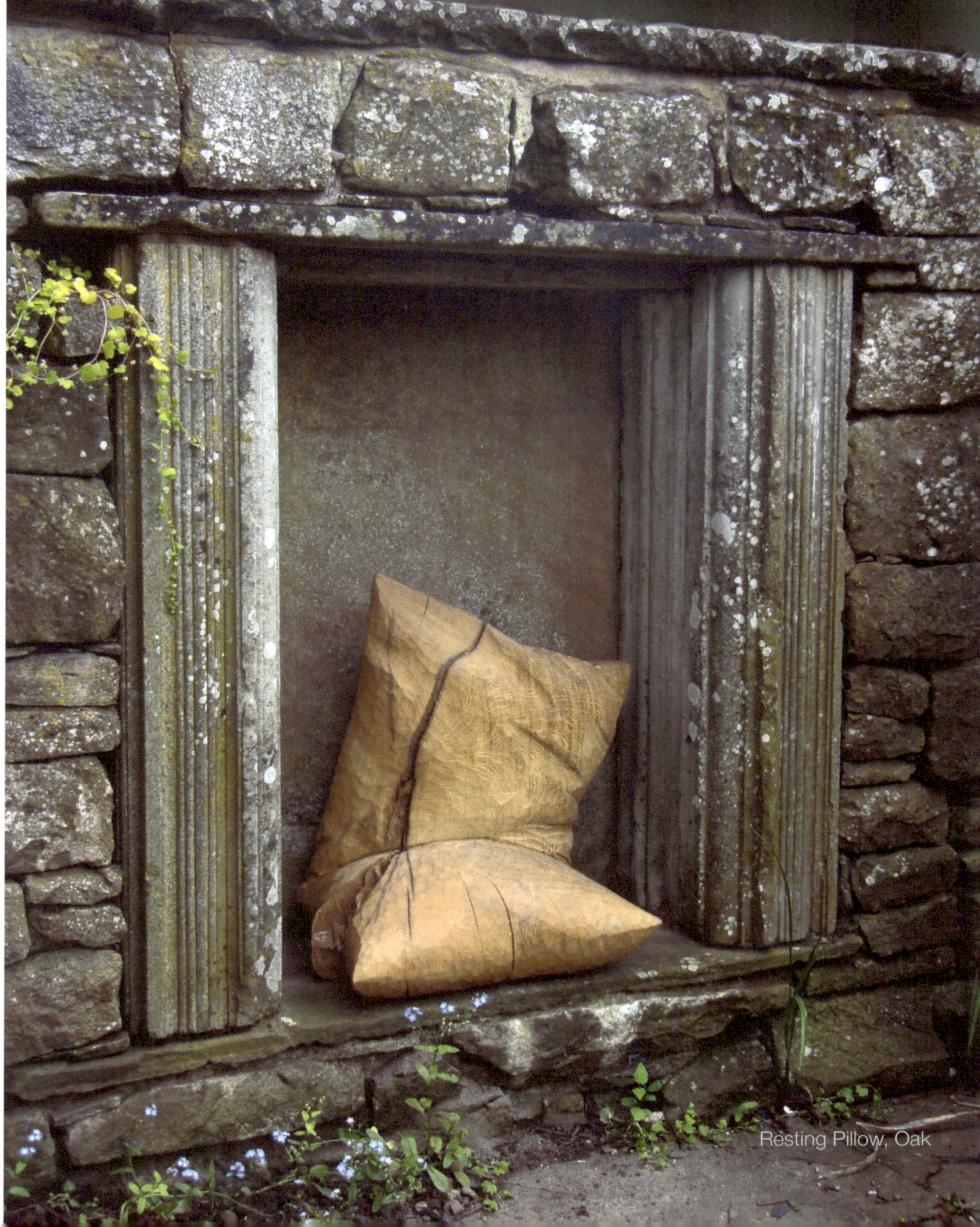
Resting Pillow, Oak

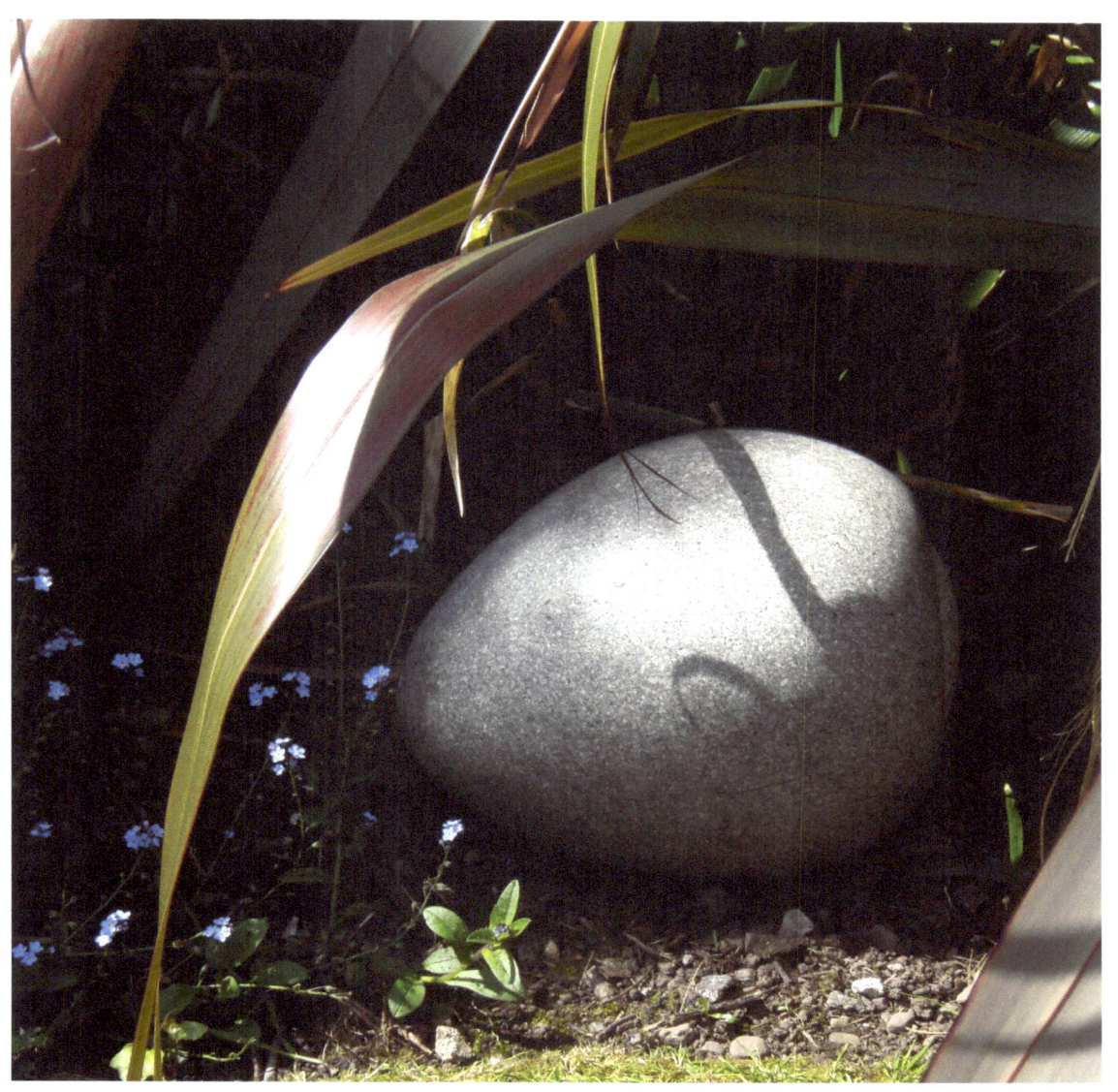

Nut, Granite

The windows developed from wooden pictures which were carved from single pieces of solid wood. The idea with these portraits of wood was to elevate the material from its position of subservience to that of the image to be admired - the painting; the material itself becoming the subject matter. The focus is on what is usually ignored. The aim is to poke people slightly, an attempt at encouraging the viewer to feel the fundamental materiality and beauty of the wood.

While using the time honored method of framing to enhance the subject, I have become interested in the framing device itself. The windows frame larger views but are still playing with the viewer's perception of the subject matter/view. Why is a framed view a more intense experience? A vast landscape such as that which surrounds Plas Brondanw is overwhelming. The framing of a landscape, I think, allows a private view, a more intimate relationship with the subject. At Plas Brondanw, Clough Williams-Ellis was well aware of this and used various devices, for instance, the garden's axis designed to frame Cnicht, an extremely dramatic peak in the Snowdon range.

The frames on stands also refer to the days when a painter or draftsperson would employ a frame to more easily and accurately capture the image to be painted. So by extension the viewer is being encouraged to become the artist.

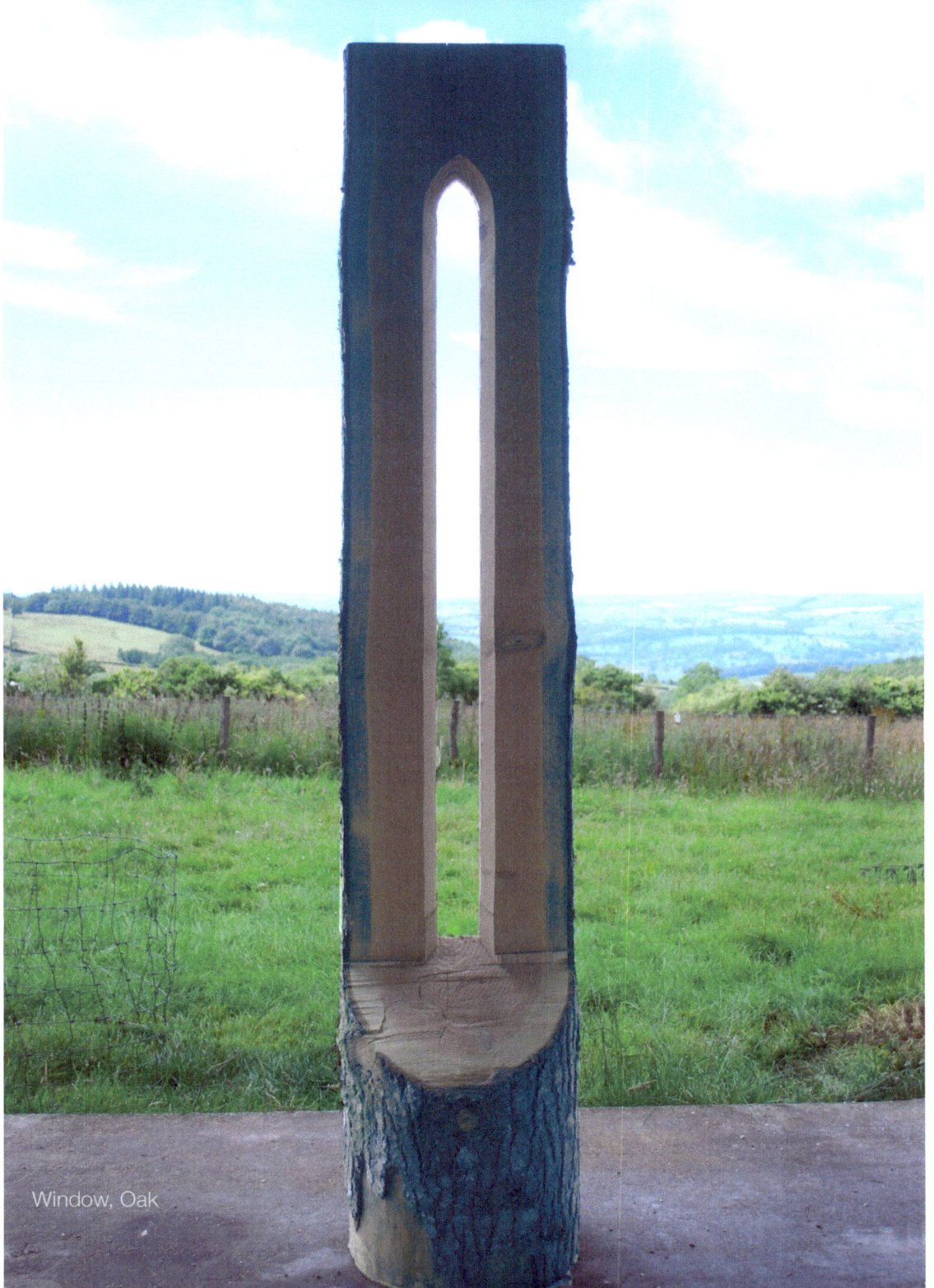
Window, Oak

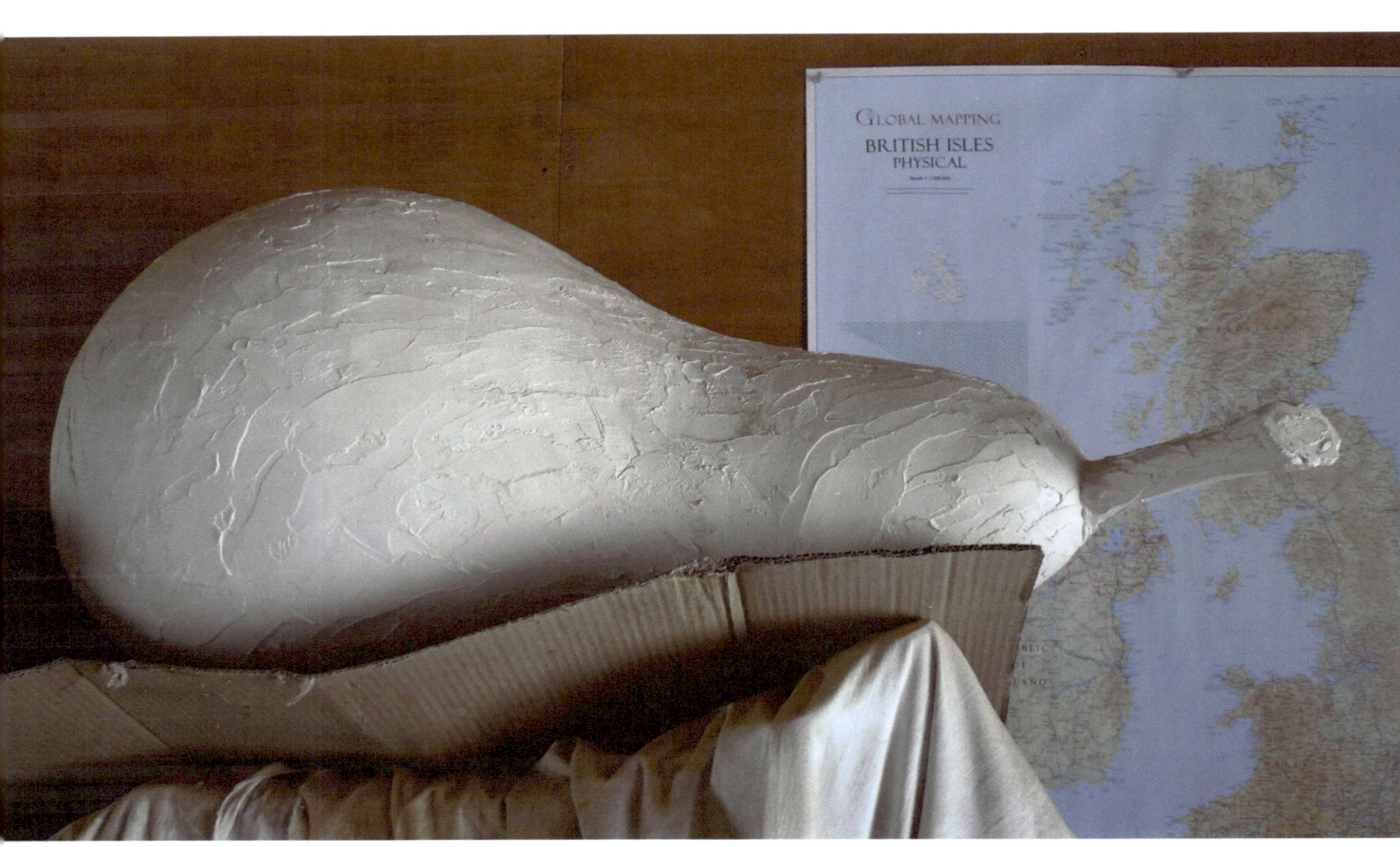

Pear, Plaster of Paris

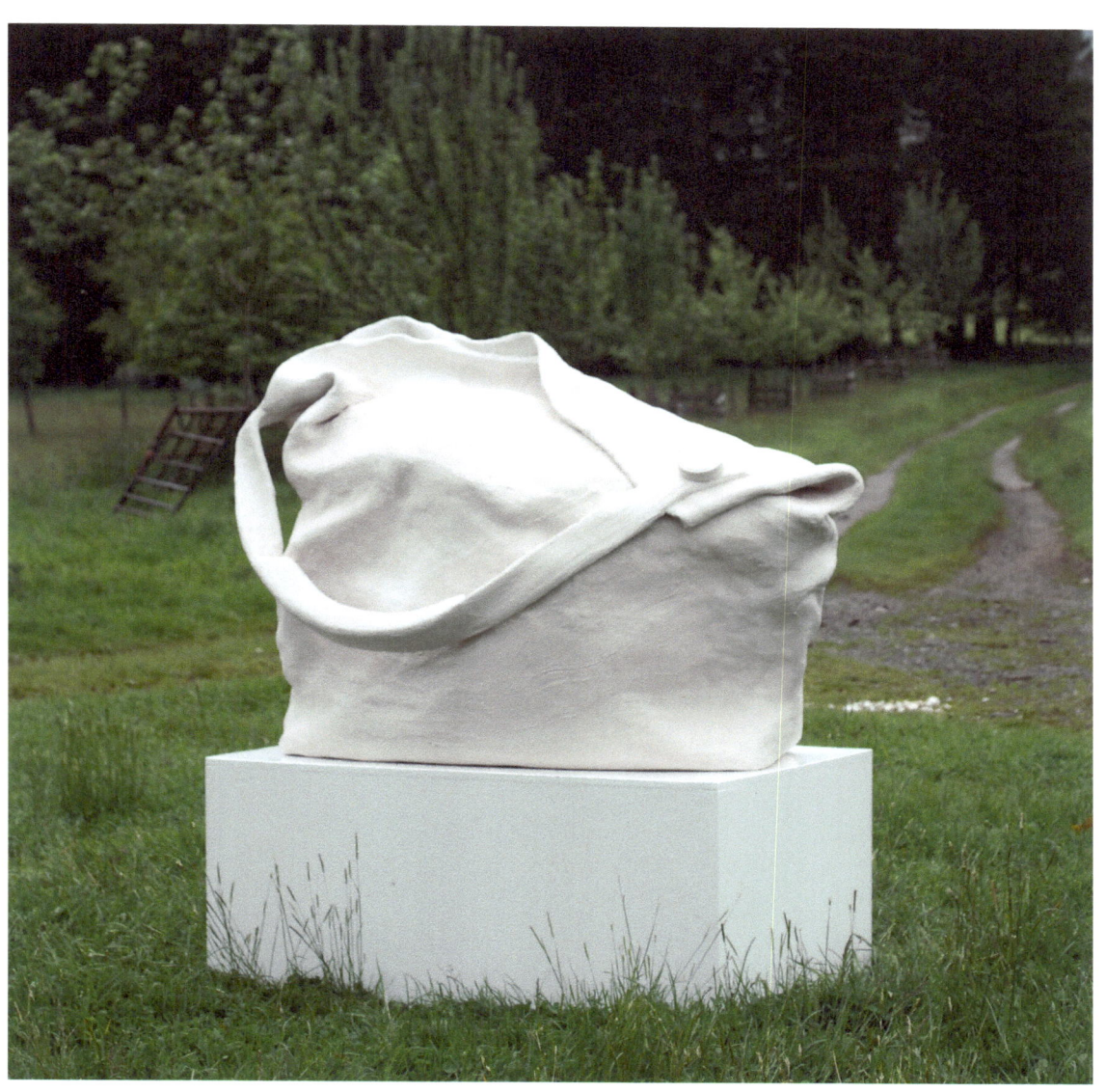

Mum's Handbag, Plaster of Paris

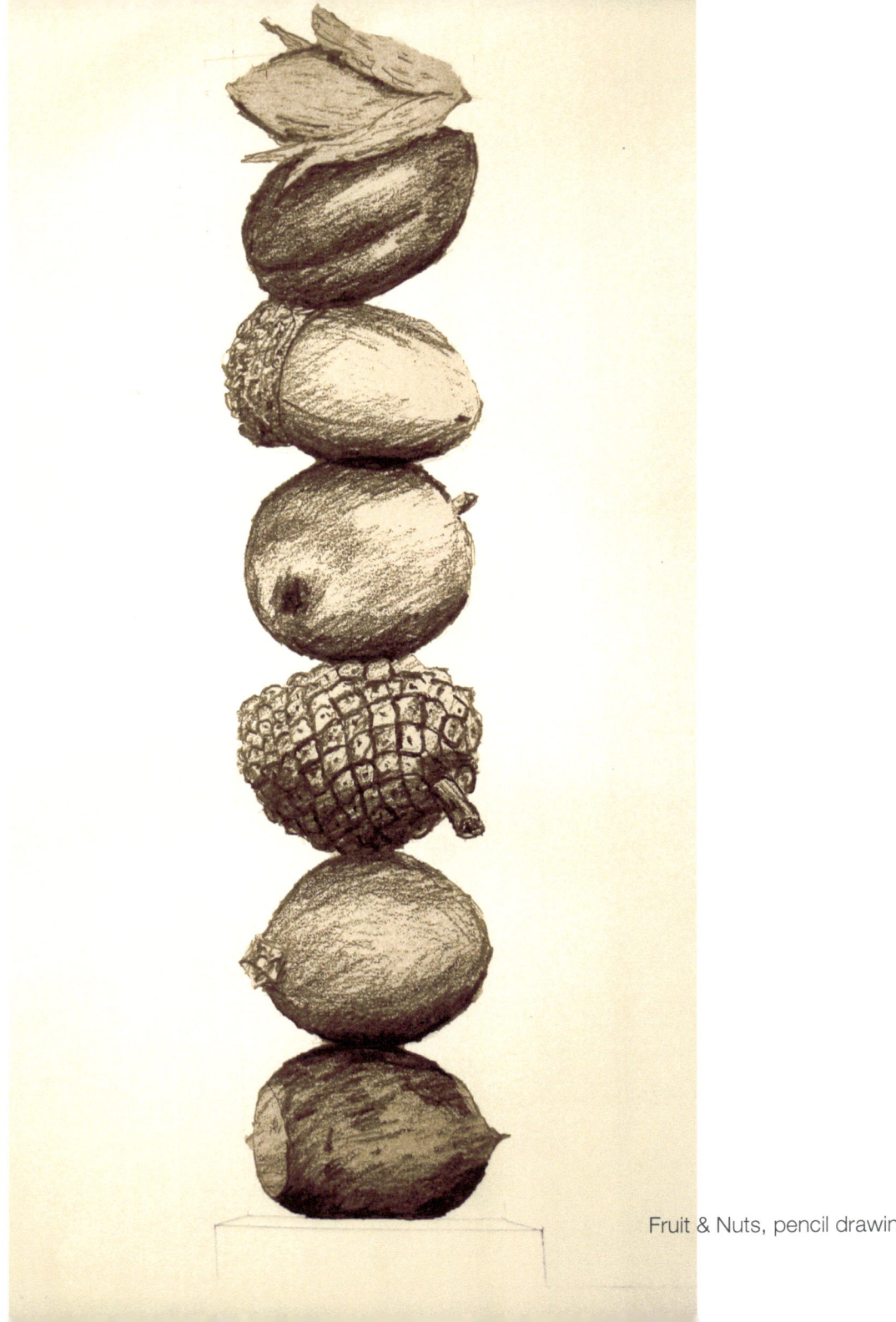

Fruit & Nuts, pencil drawing

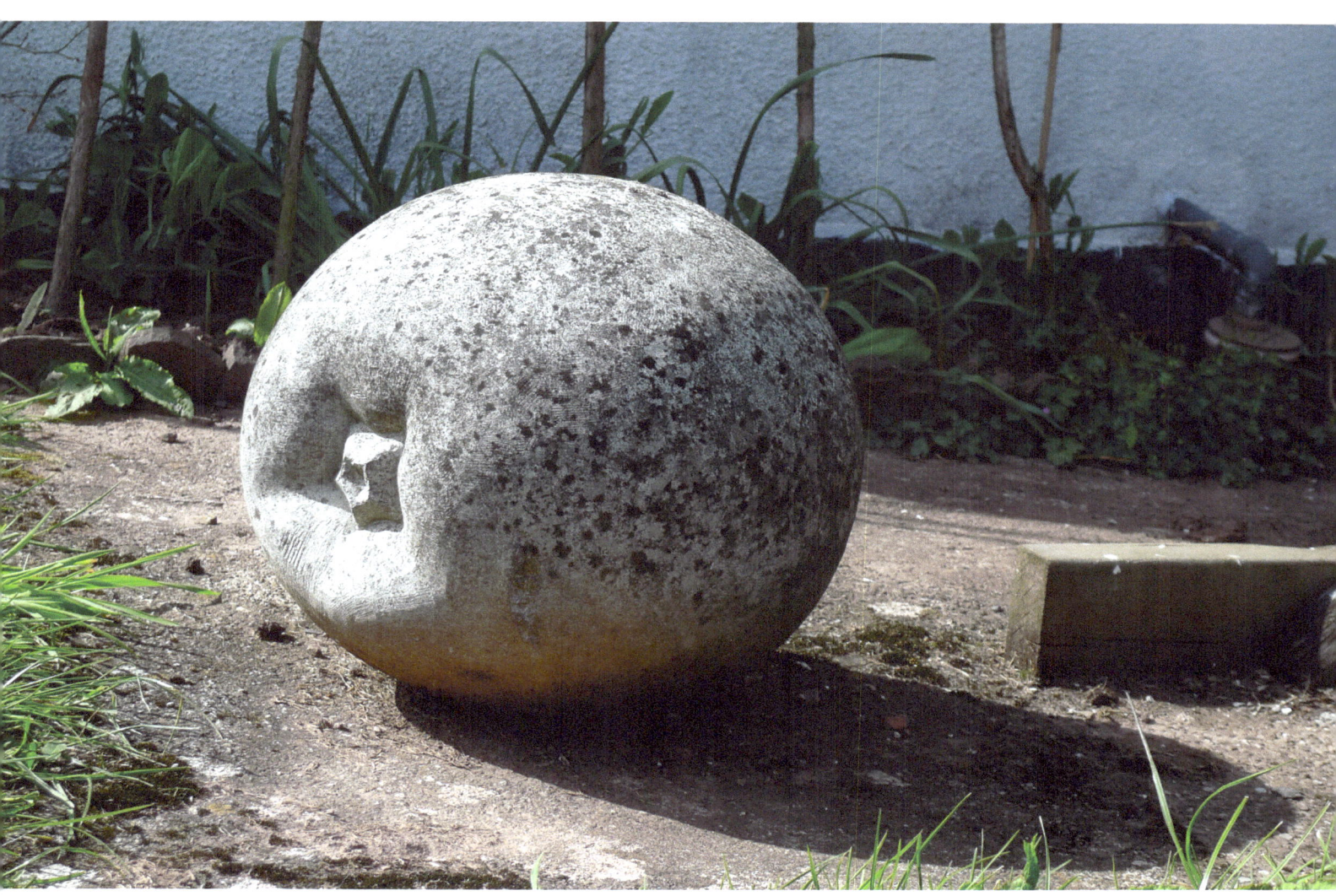

Apple, Limestone

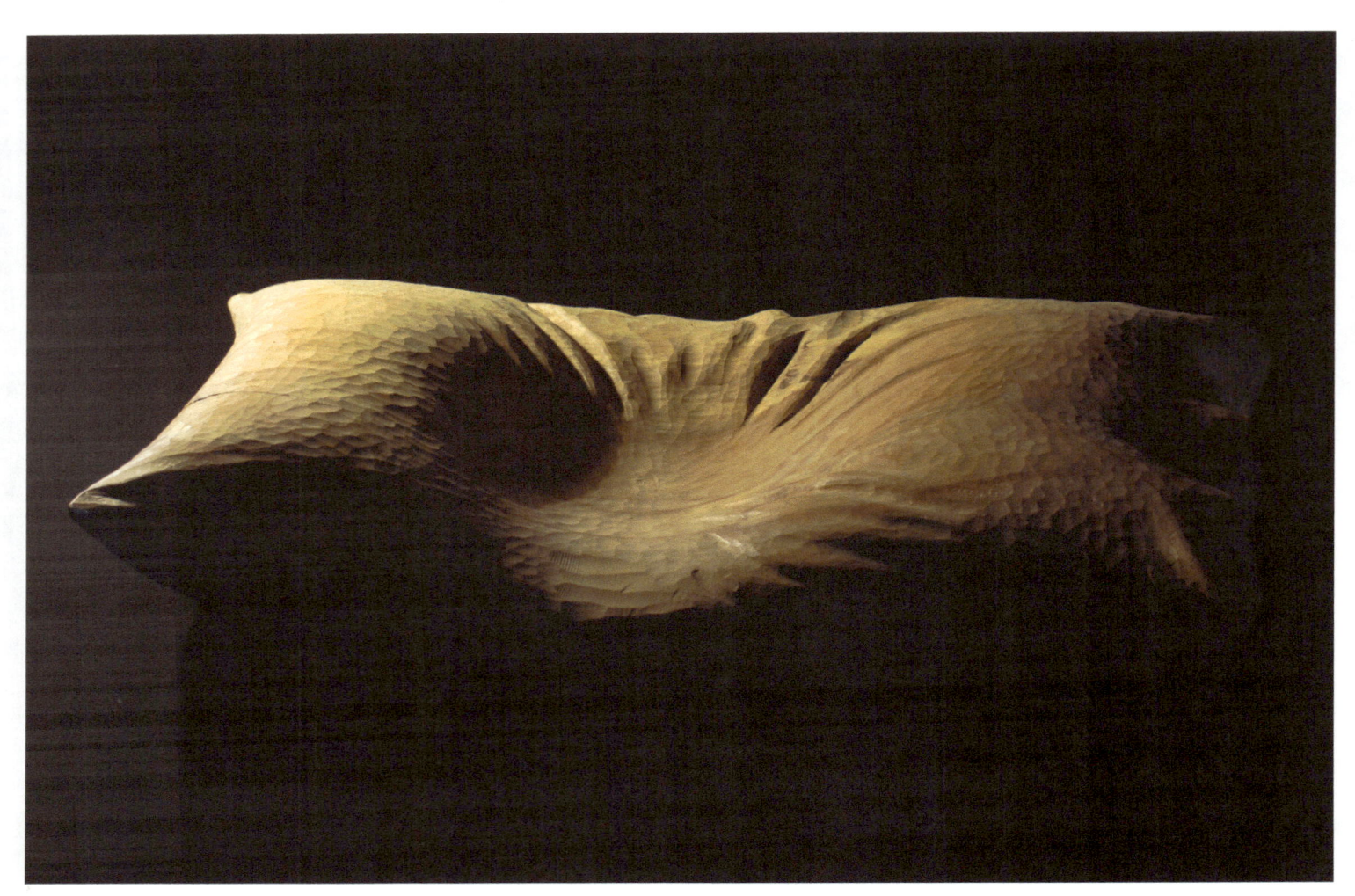

Pillow, Beech

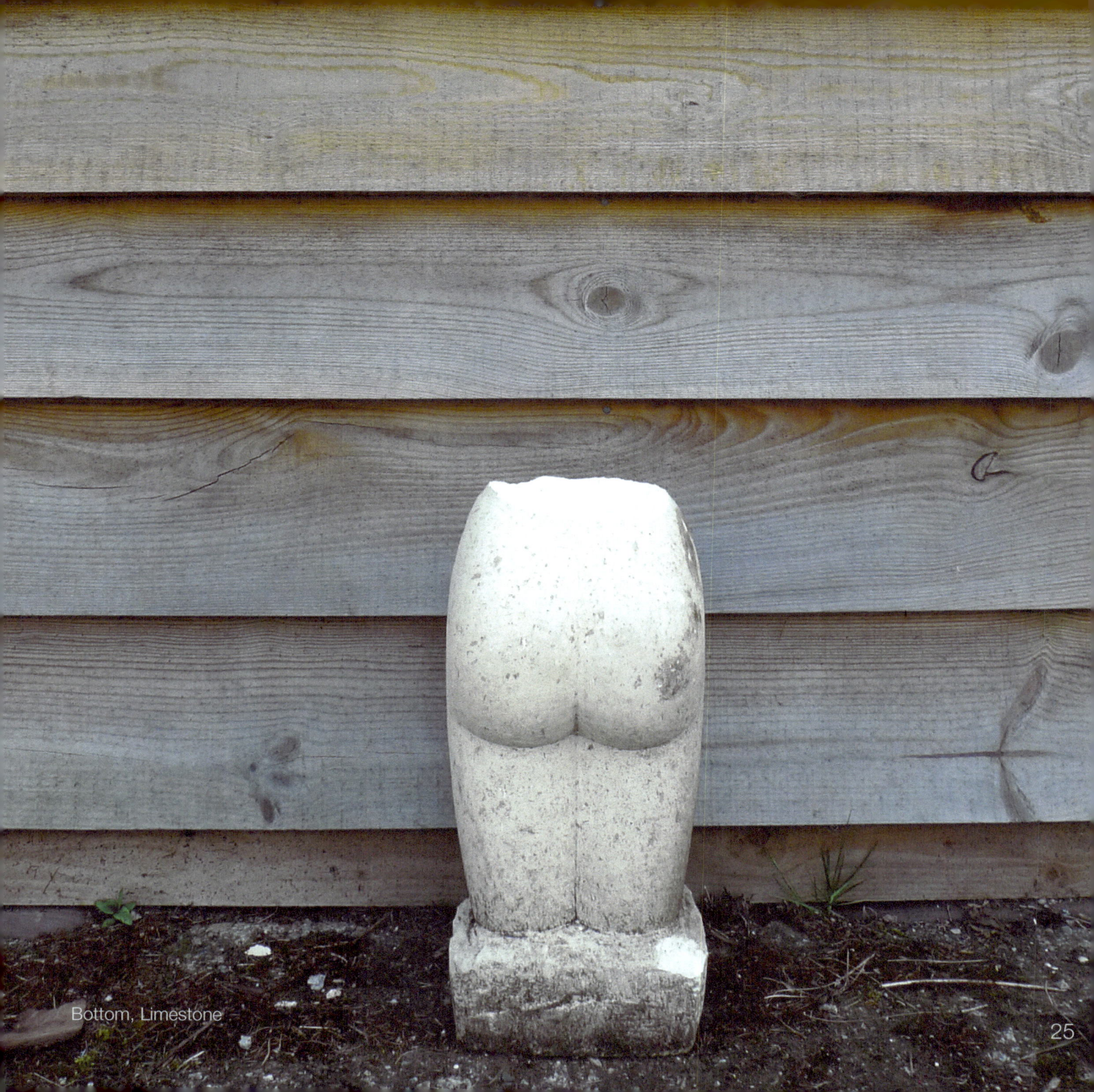

Bottom, Limestone

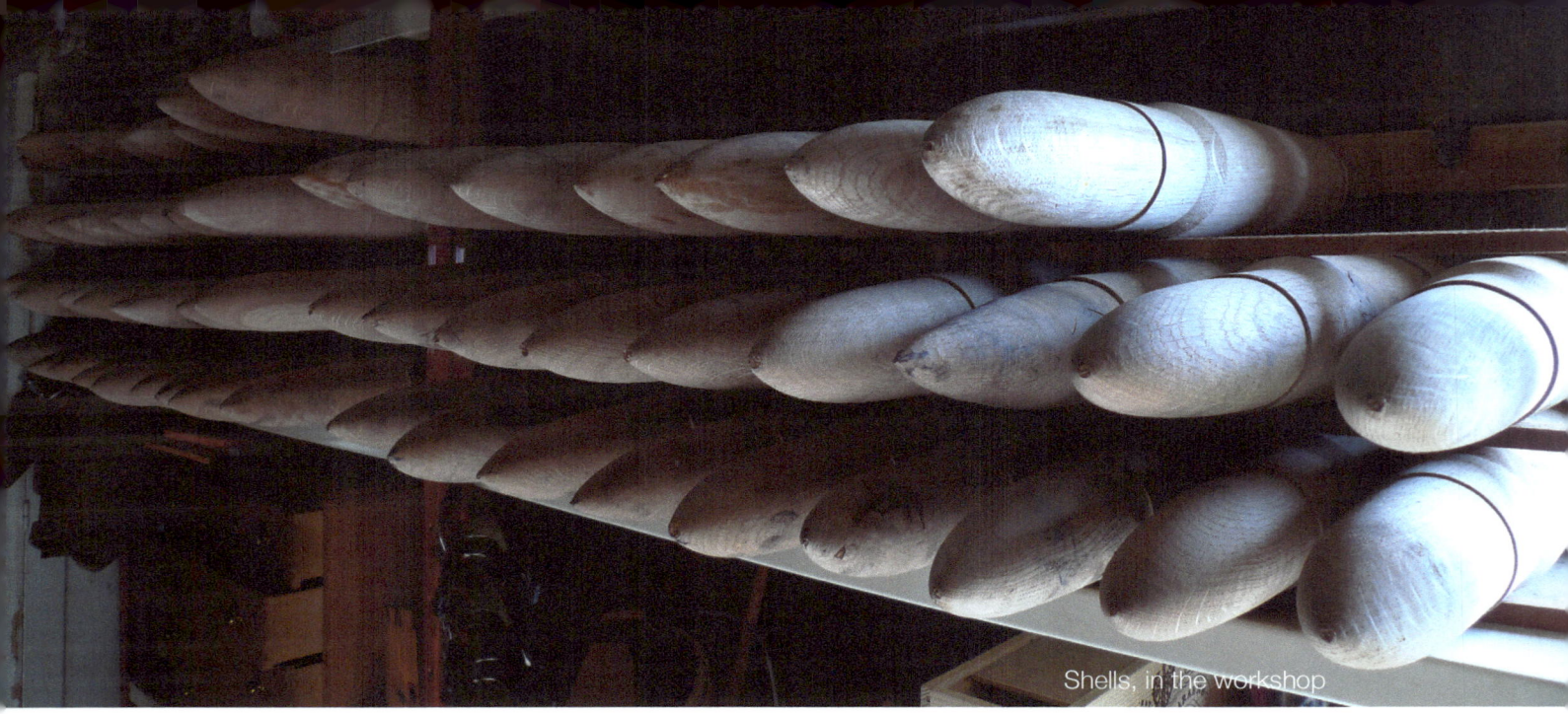
Shells, in the workshop

These shells are turned in green oak using a lathe, they are made in response to my constant amazement at how dreadfully humans treat each other on a regular basis. Being a parent and idealist and a sometimes optimist, I can't help but compare the reality of our worldwide situation with dreams of a peaceful, sharing future. Planting the shells in a garden brings together many ideas and signifiers: the magnificent effulgence of nature with the darker, destructive habits of humans, the beauty and peace one expects in a garden with the scrabbling desires to dominate. Wood turning, these days a gentile hobby, is used here to portray objects which are mass produced expressly for killing. Planted thus as vegetables they remind me eerily of the cemeteries in Normandy, where the pride of a whole generation lies.

Making these shells with what is now largely a domestic craft in a loving environment poses the question 'why is there such a disparity between our international attitudes and our local or domestic ones?

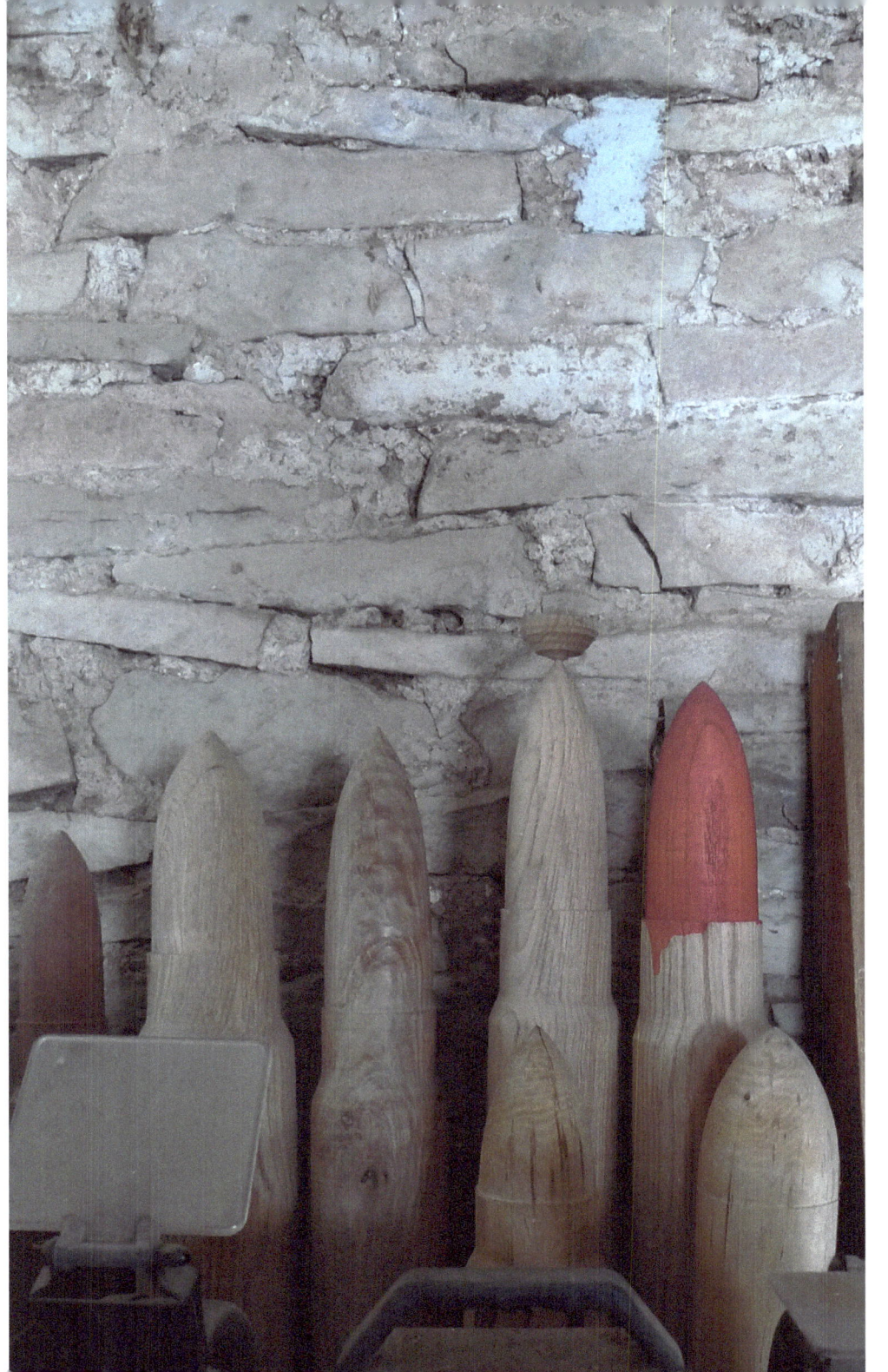

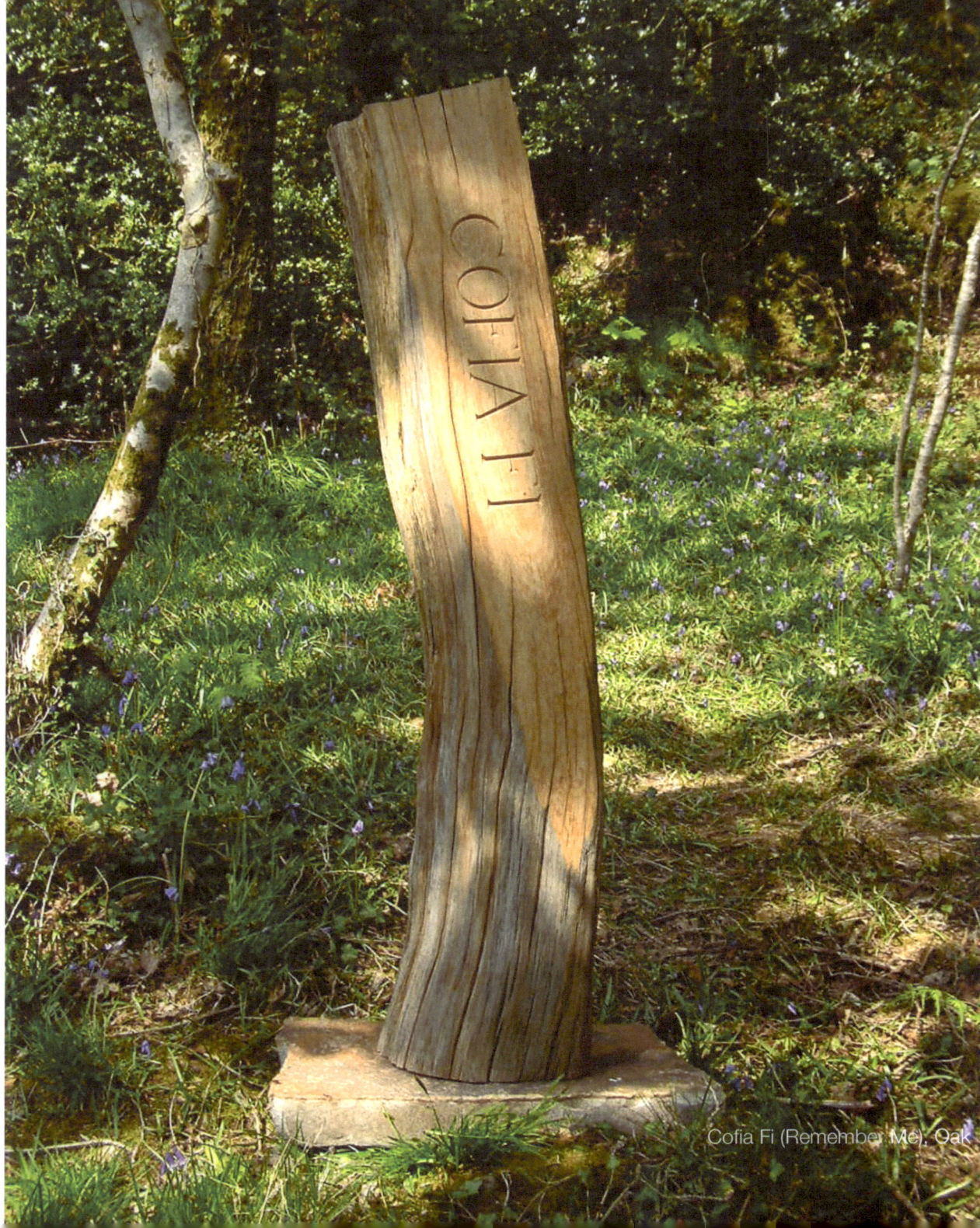

Cofia Fi (Remember Me), Oak

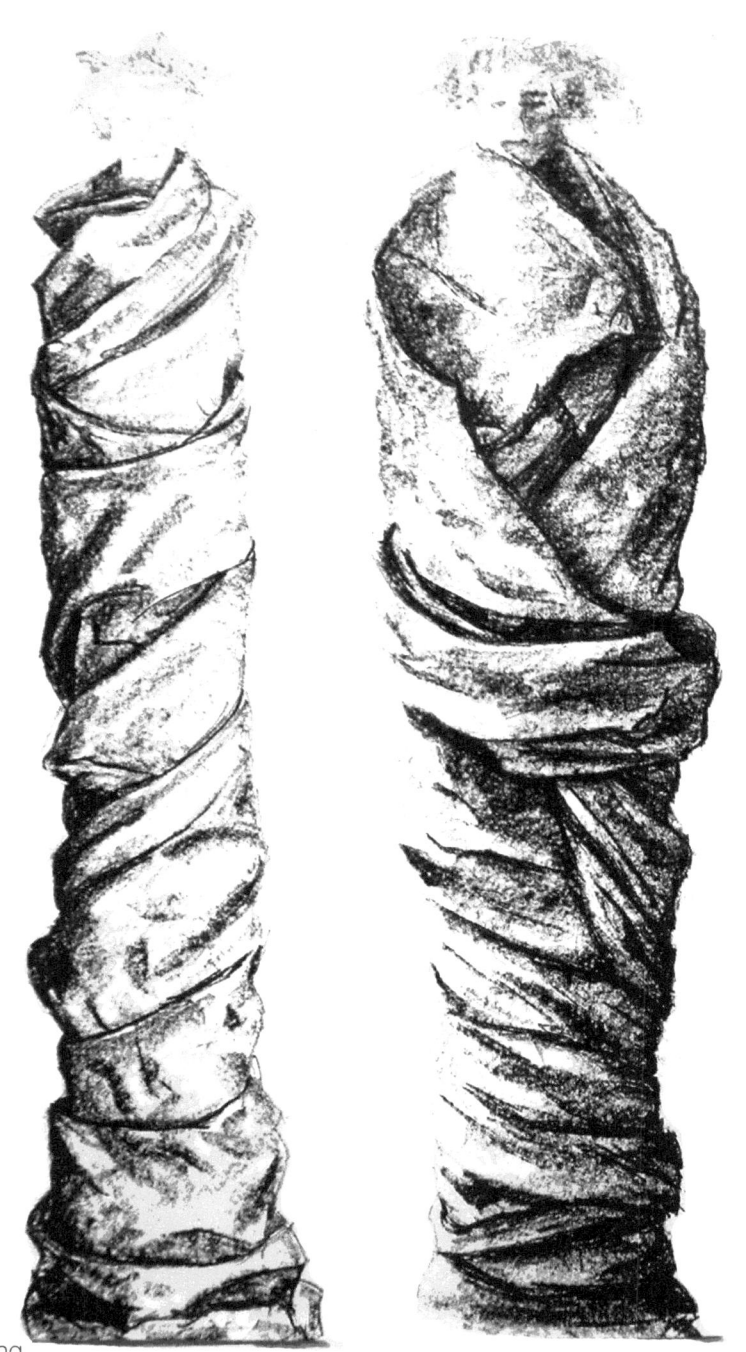

Lazarus, charcoal drawing

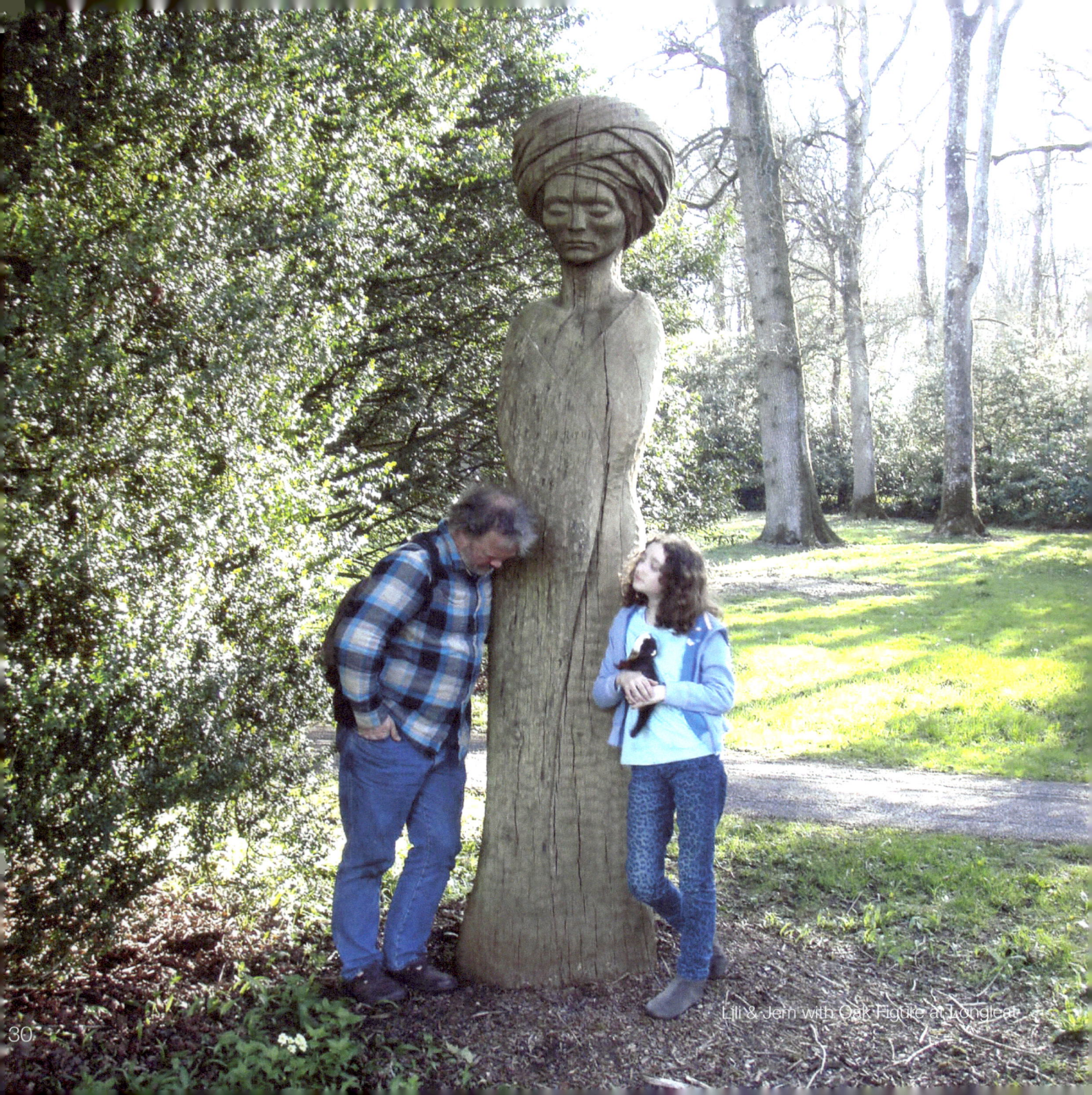

Lili & Jem with Oak Figure at Longleat

Making art is a meditative process. Carving a piece of stone or wood is lengthy process during which the mind mulls gently on the meaning of the piece and may find it to be much deeper and more meaningful than the initial concept. An artwork is an invitation to dialogue where it is the intermediary between artist and viewer. Yet the artist must let the piece go once it is displayed or finished, they can only put forward suggestions, hints which the viewer is at liberty to ignore, misinterpret or find something completely different. So the viewer is actually a creative participant and the artist may discover new and perhaps, unexpected meanings in the work.

Portrait of Lili aged six months, Bronze

www.jemstiff.co.uk

jemstiff@hotmail.co.uk

This book published on the occasion of an exhibition in the gardens
Plas Brondanw, Gwynedd, 2014.

Further copies may be ordered from here:
http://www.lulu.com/content/paperback-book/jeremy-stiff-sculptor/14952191]